Other NEW YORKER *books*

The New Yorker Book of All-New Cat Cartoons

The New Yorker Book of Cat Cartoons

The New Yorker Book of Dog Cartoons

The New Yorker Book of Lawyer Cartoons

The New Yorker Book of Doctor Cartoons

The Complete Book of Covers from *The New Yorker,* 1925–1989

The Art of *The New Yorker,* 1925–1995, *by Lee Lorenz*

THE
NEW YORKER
BOOK OF TRUE LOVE CARTOONS

THE
NEW YORKER
BOOK OF TRUE LOVE
CARTOONS

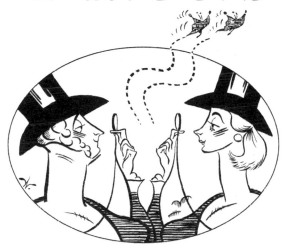

ALFRED A. KNOPF NEW YORK 1999

THIS IS A BORZOI BOOK
PUBLISHED BY ALFRED A. KNOPF, INC.

Copyright © 1999 by The New Yorker Magazine, Inc.

All rights reserved under International and Pan-American Copyright
Conventions. Published in the United States by Alfred A. Knopf, Inc.,
New York, and simultaneously in Canada by Random House of Canada Limited,
Toronto. Distributed by Random House, Inc., New York.

www.randomhouse.com

ISBN 0-375-40313-2
LC 98-89400

Manufactured in the United States of America
First Edition

THE
NEW YORKER

BOOK OF TRUE LOVE CARTOONS

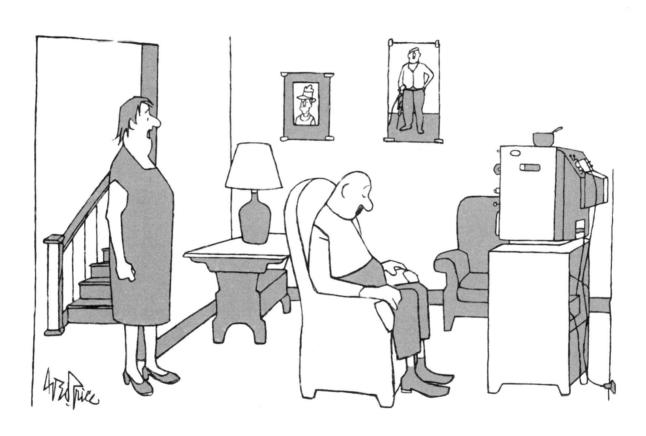

"*Yoo-hoo. Time to climb the stairway to paradise.*"

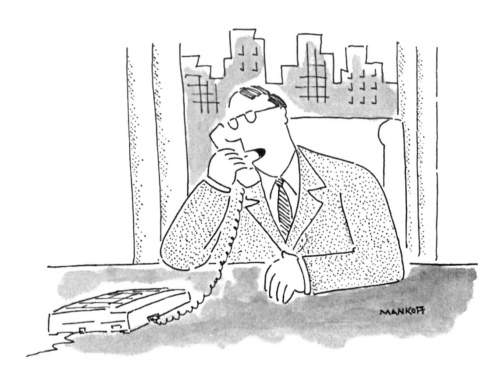

"*Let's do it, let's fall in love.*"

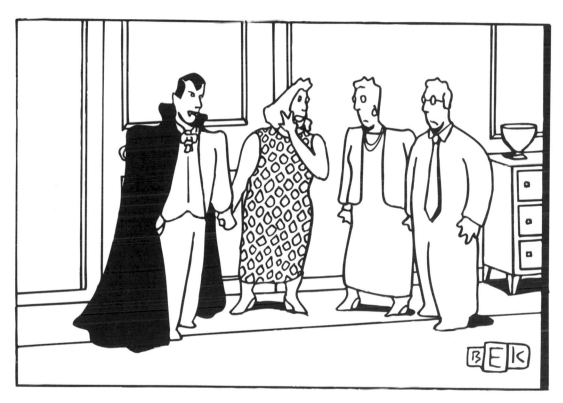

"*I know. But I think I can change him.*"

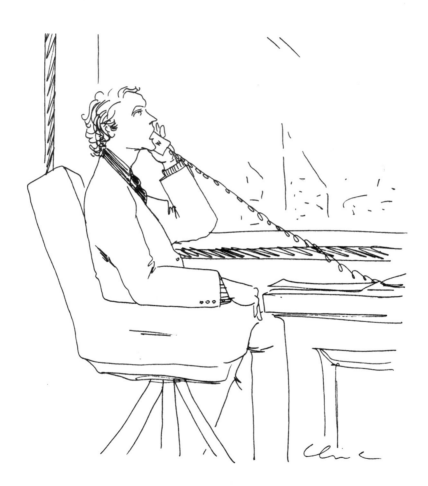

"Kathy, I'm updating my files. Do you still love me?"

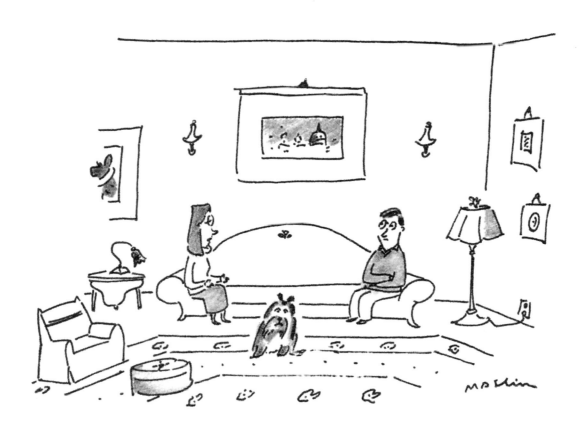

"All right, I was wrong. A Shih-Tzu was __not__ all that was missing from our marriage."

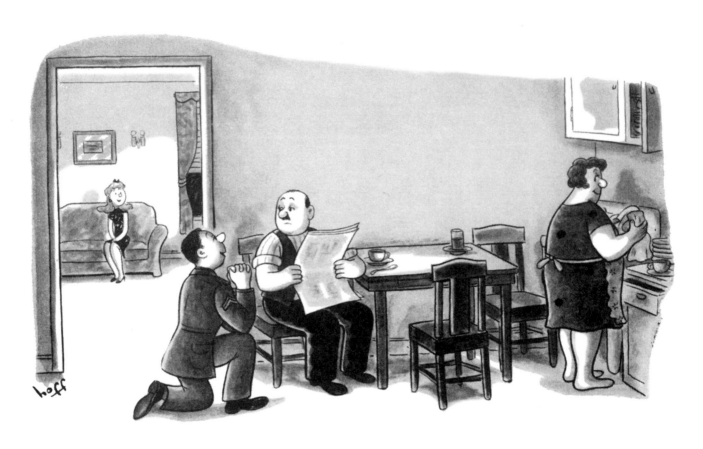

"It's about a certain member of your family, Mr. Kopik."

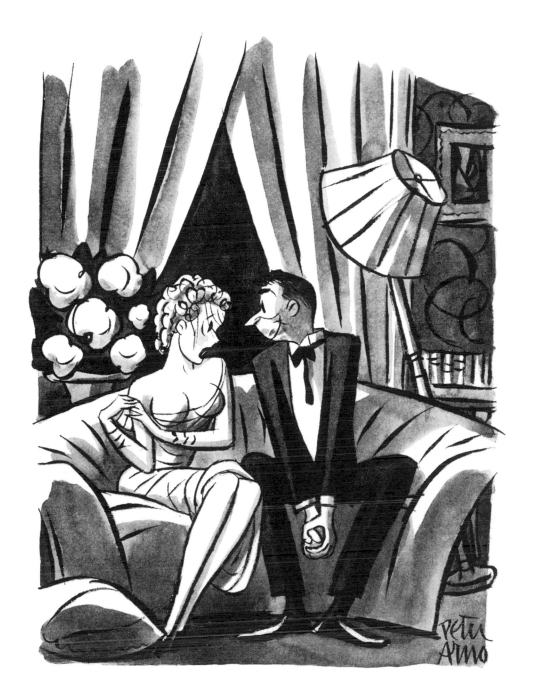

"Now let's talk about you!"

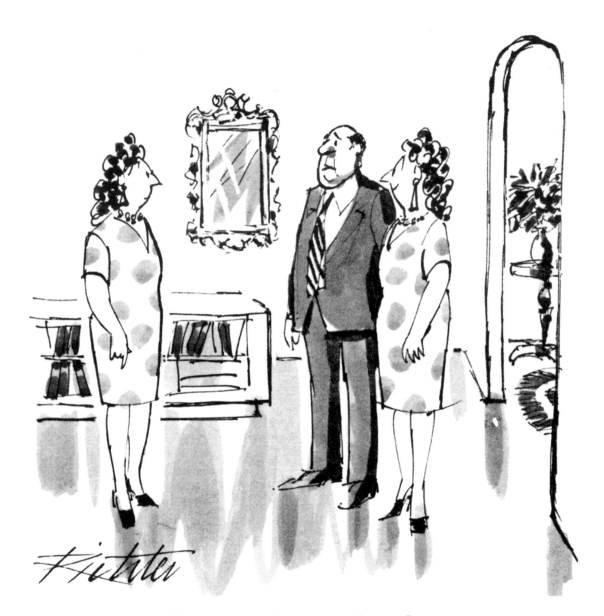

"I can't keep it from you any longer, Irene.
This is the other woman."

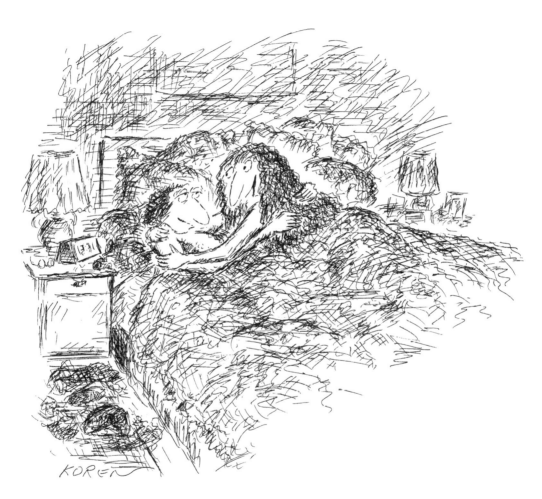

"Is this a good time to bring up a car problem?"

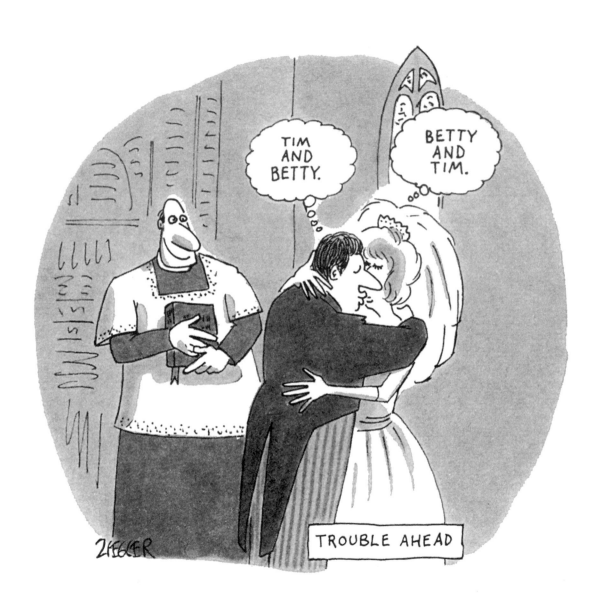

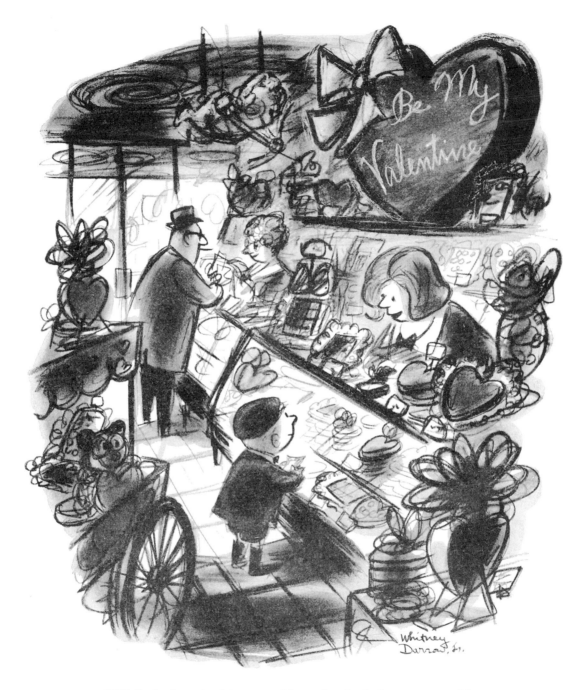

"*Well, look at it this way. How deeply in love are you?*"

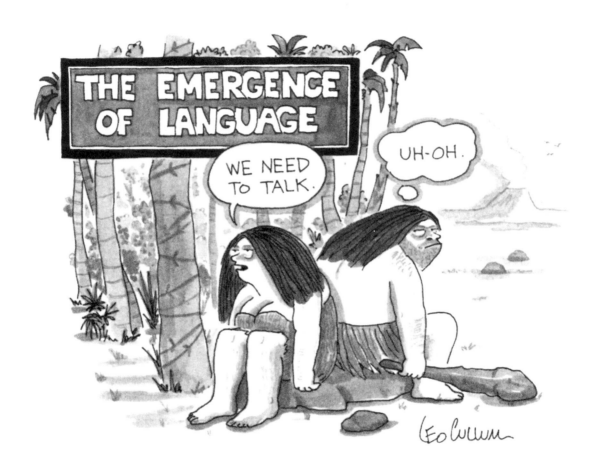

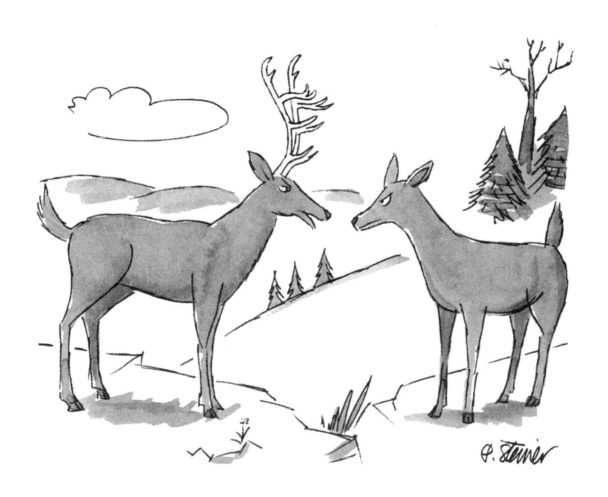

"So I like rutting. So sue me."

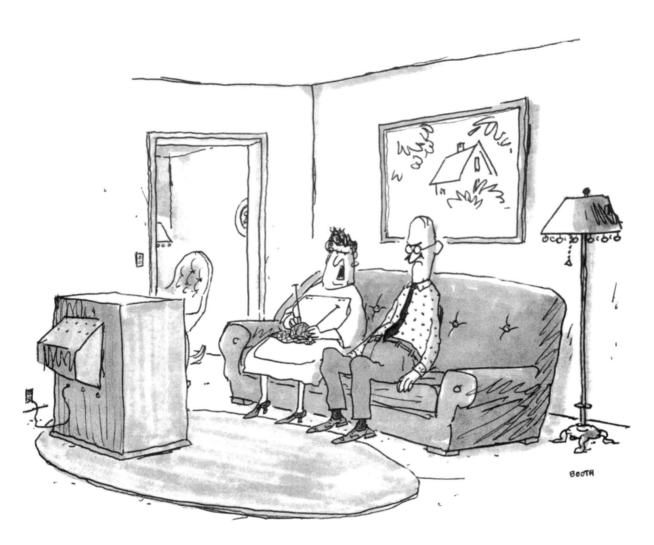

"If I die first, you should remarry. If you die first, I'll get a dog."

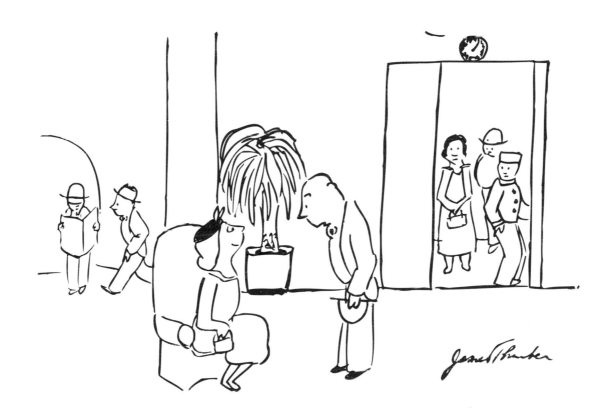

"You wait here and I'll bring the etchings down."

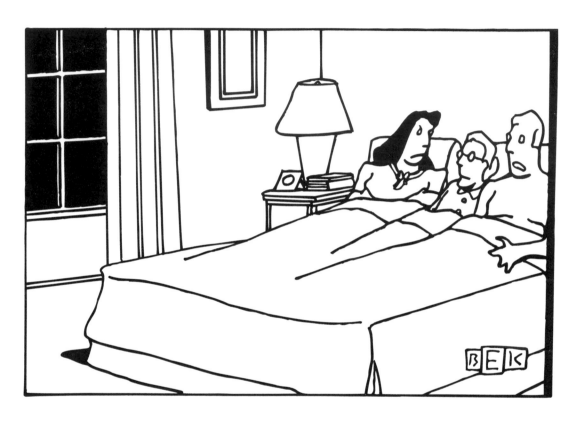

"*For heaven's sake, Melissa, she's my mother. I can't tell her to leave.*"

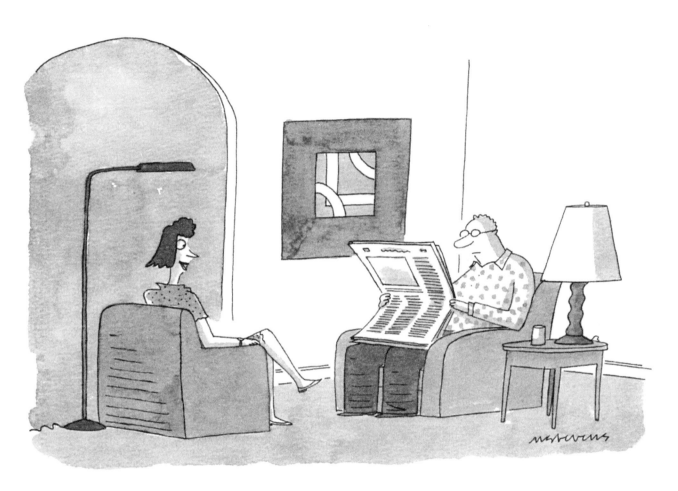

"I think it might help us to understand one another better
if you waited on me hand and foot for a while."

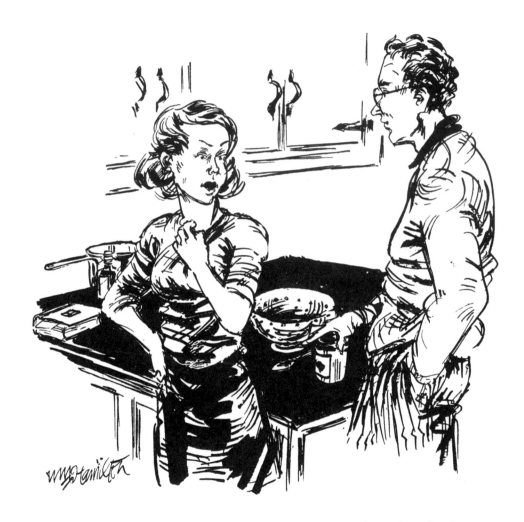

"Oh, you were on automatic pilot? And what about her?
Was she on automatic pilot, too?"

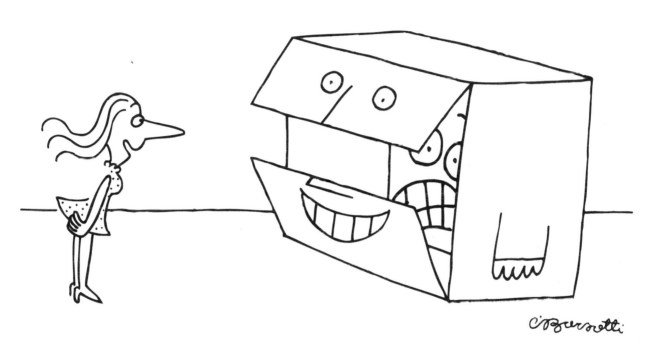

"Oh, Stanford, I'm touched. Trust is <u>such</u> an important first step."

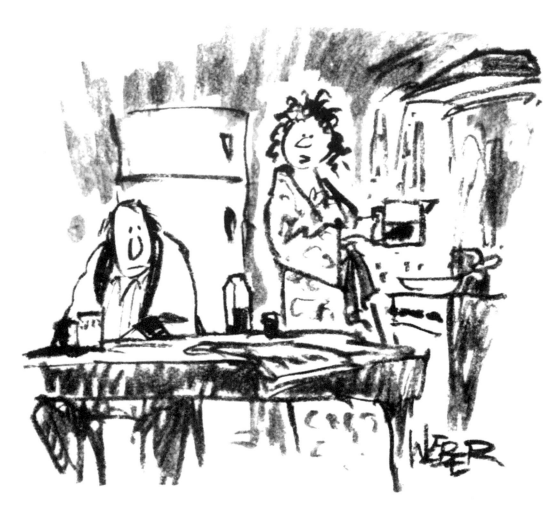

"It's not that we had more fun before we got married—it's just
that now we're having a different kind of fun."

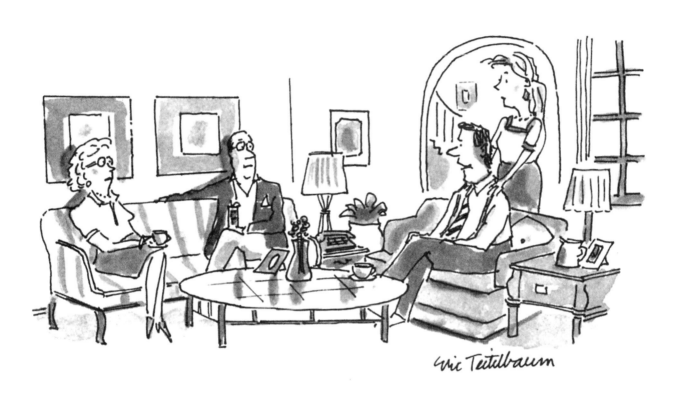

"Mr. and Mrs. Ackerman, I'll come to the point. I'm deeply in love with your daughter, and I'd like to move in with you."

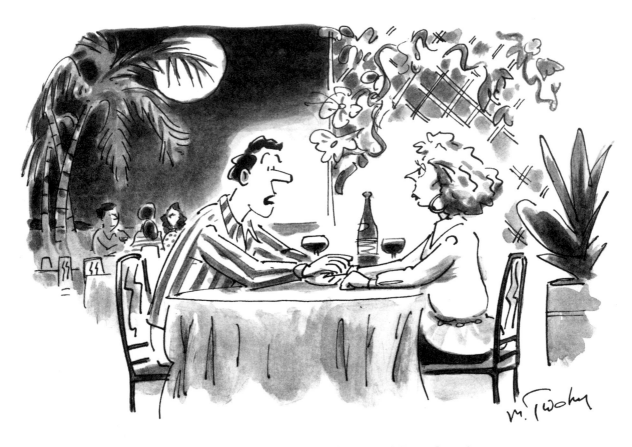

"*Don't you understand? I love you! I need you!*
I want to spend the rest of my vacation with you!"

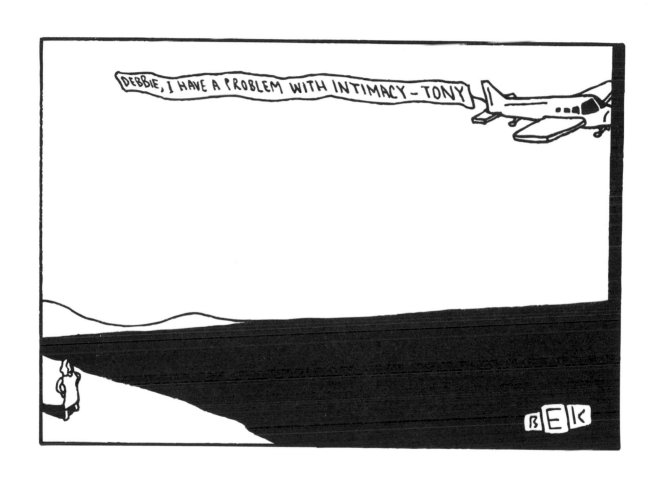

23

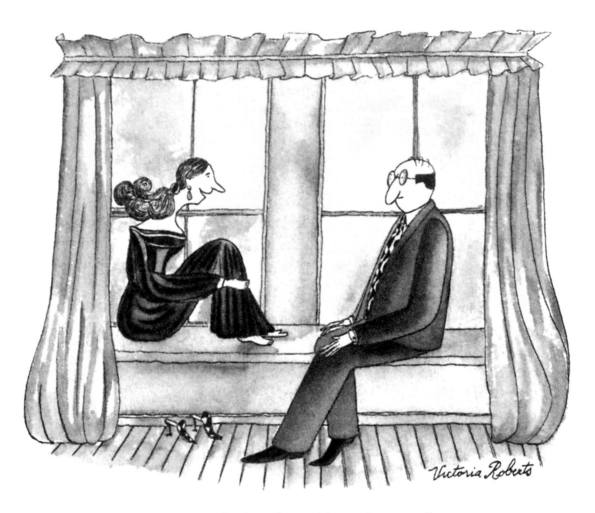

"*I'm inside the cake waiting to jump out.*"

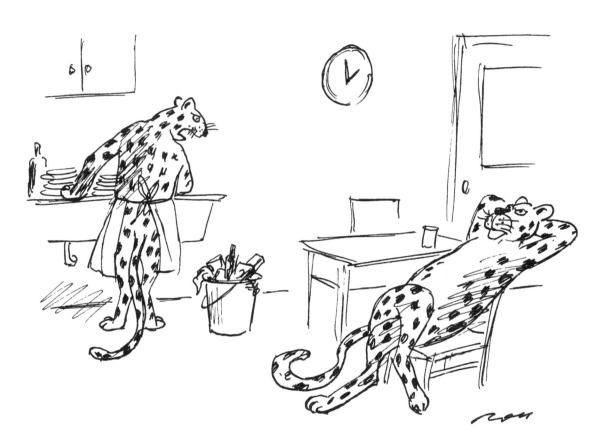

"I'm not asking you to change your spots. I'm just
asking you to take out the garbage."

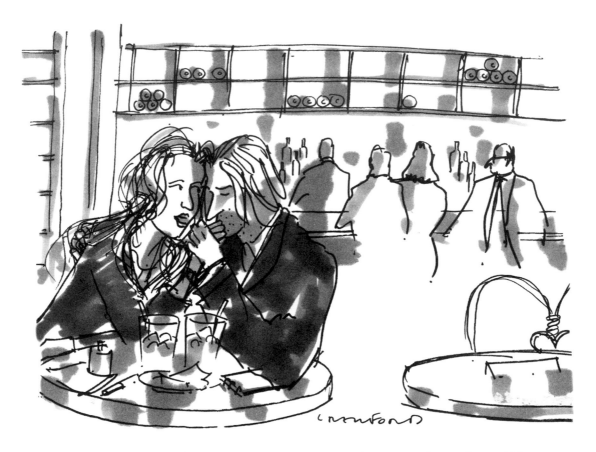

"If you quote Rilke again, I'm just going to have to take my bra off!"

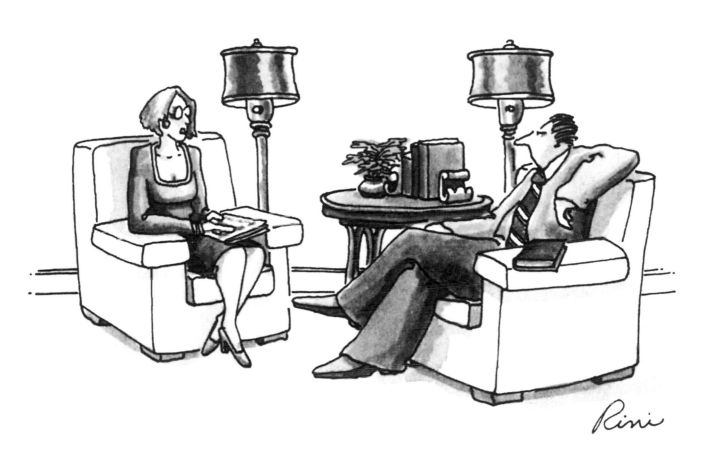

"*You may well be from Mars, but the children and I are still from Westchester.*"

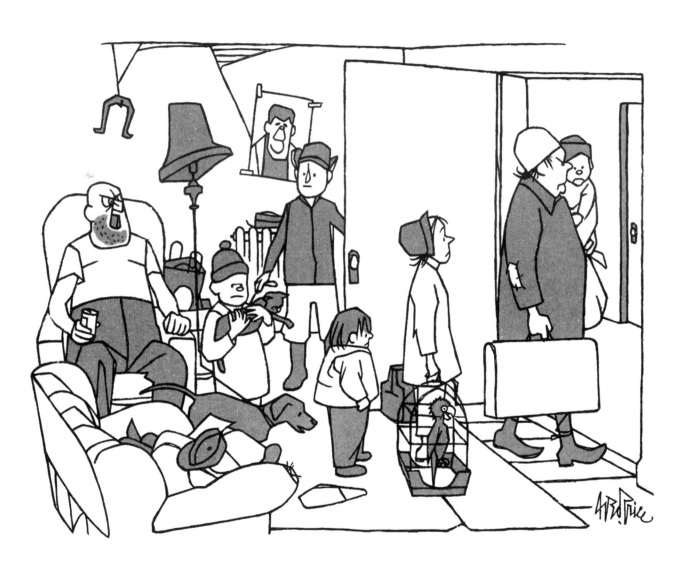

"Damn it, Maureen! You just don't break up a winning combination!"

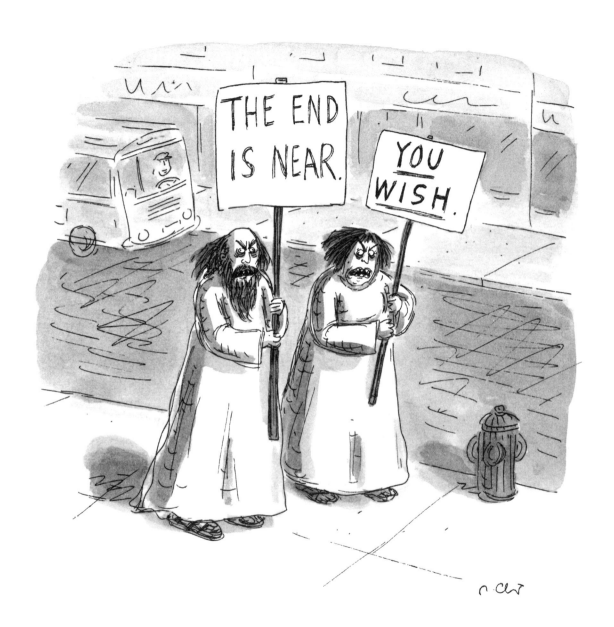

29

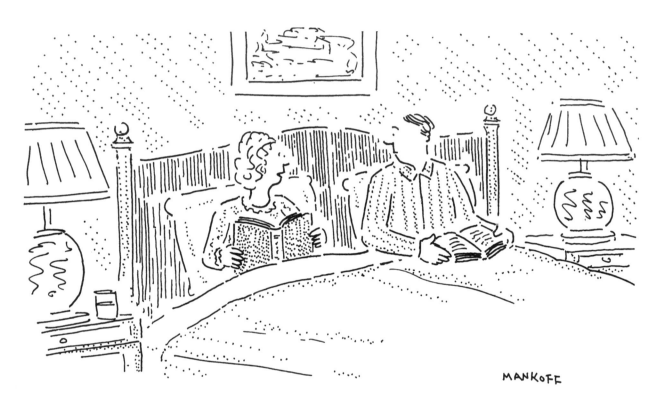

"Why, you're right. Tonight isn't reading night, tonight is sex night."

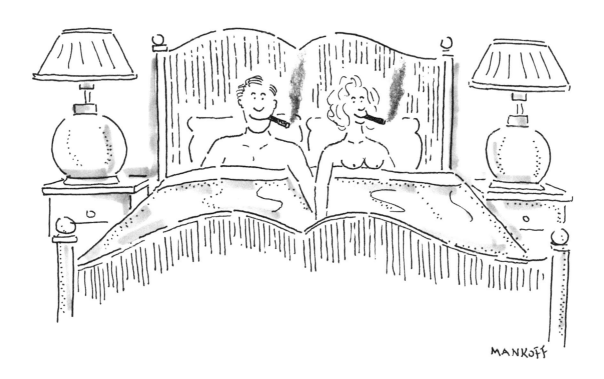

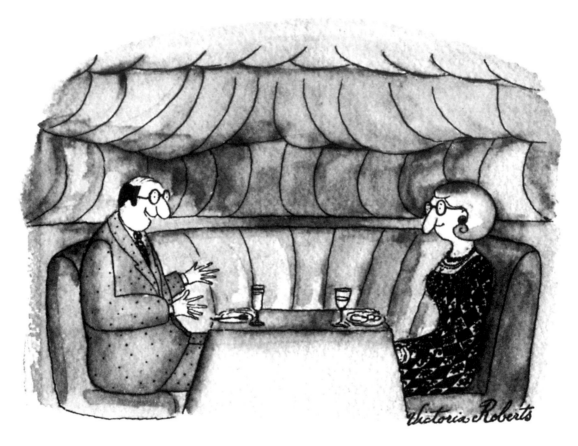

"O.K., *maybe there's no chemistry left, but there's still archeology.*"

"The thing I like about New York, Claudia, is you."

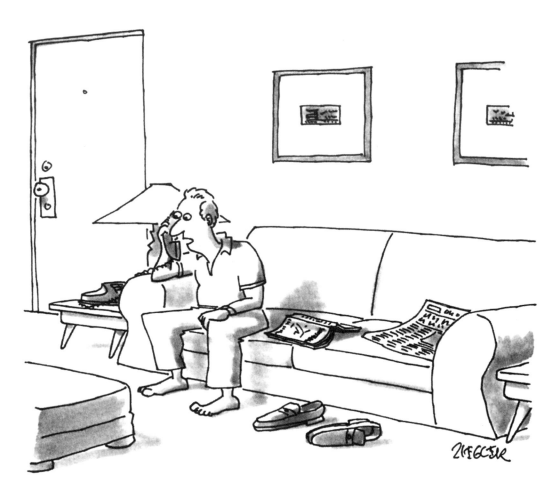

"Look, I'm doing a little me-time right now. Why don't you go ahead and do a little you-time, and then I'll be over at eight for a little us-time."

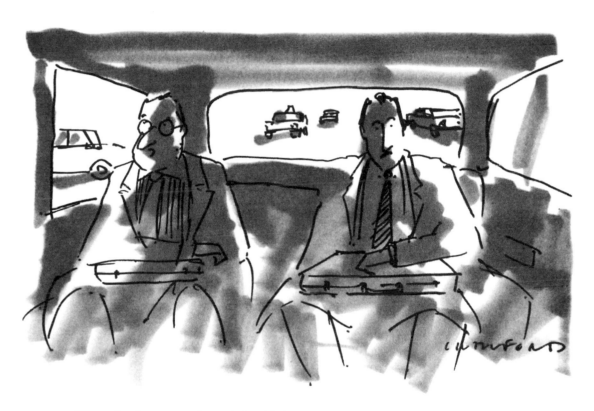

"I can't play squash tonight, Ed. I promised Linda I'd put in a little Kama Sutra time with her before the opera."

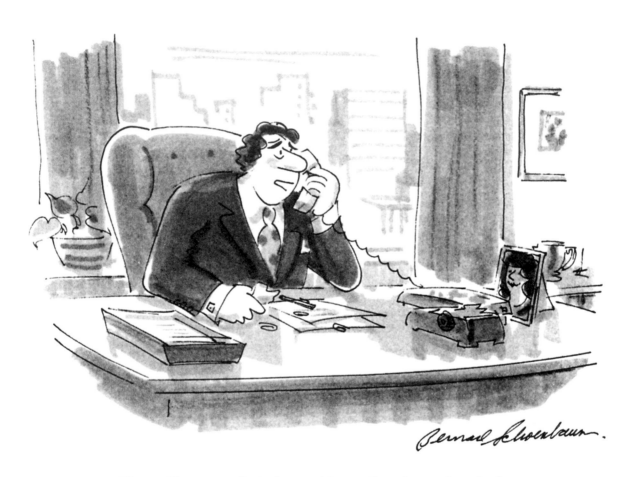

"*Joyce, I'm so madly in love with you I can't eat, I can't sleep,
I can't live without you. But that's not why I called.*"

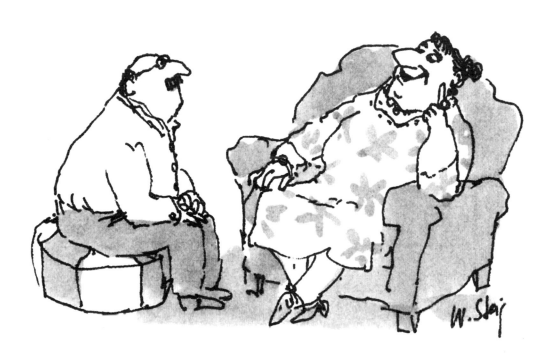

"*If you don't like my apples, why do you shake my tree?*"

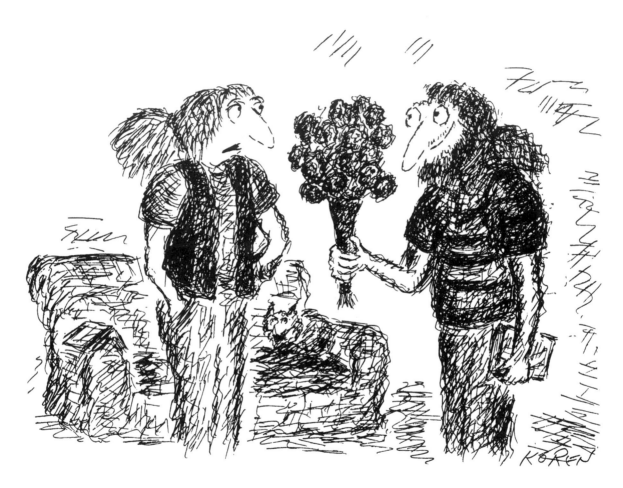

"Flowers? That's _so_ arrogant!"

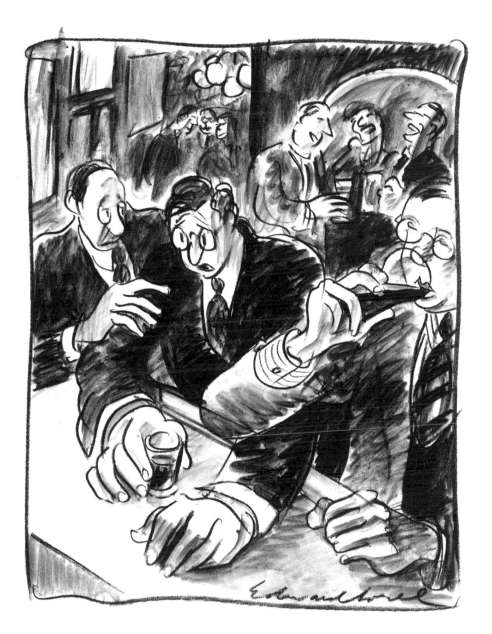

*"Before we married, she seemed like the sort
who would suffer a fool gladly."*

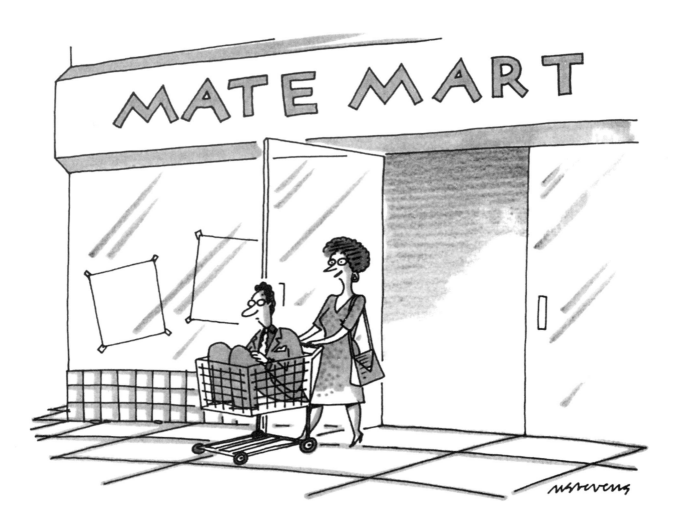

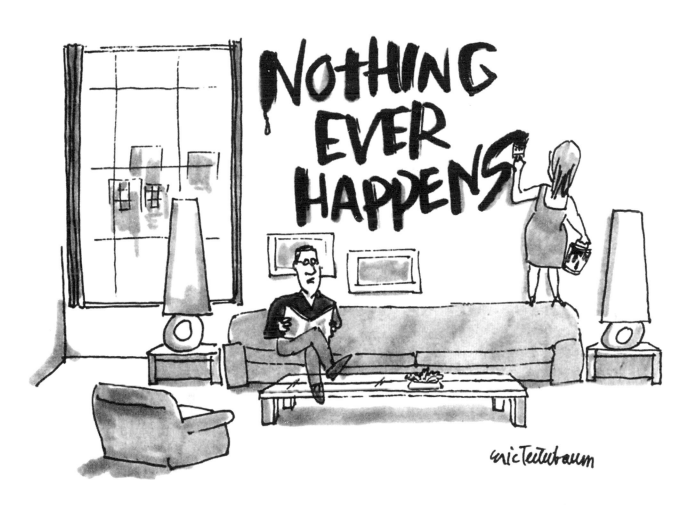

"*If something is bothering you about our relationship, Lorraine, why don't you just spell it out.*"

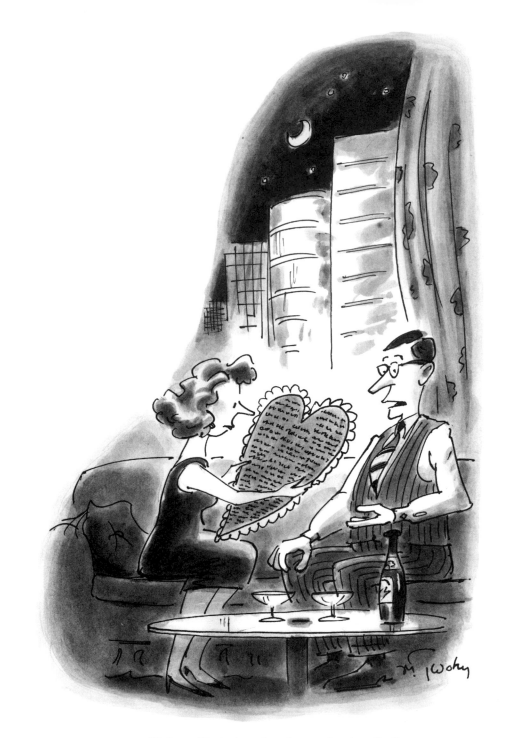

"A lot of it is just legal mumbo-jumbo."

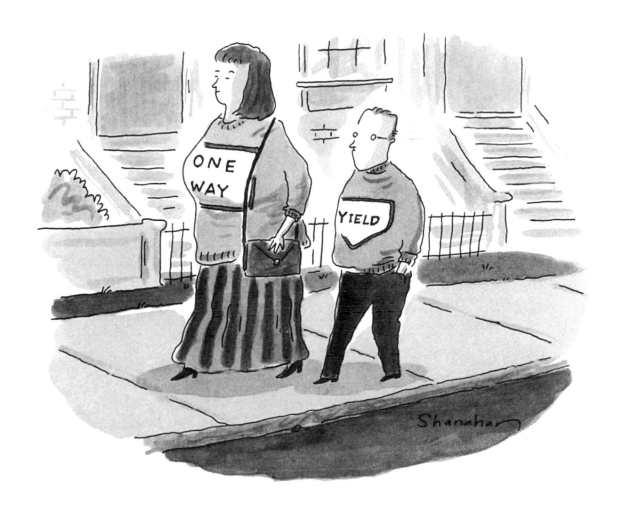

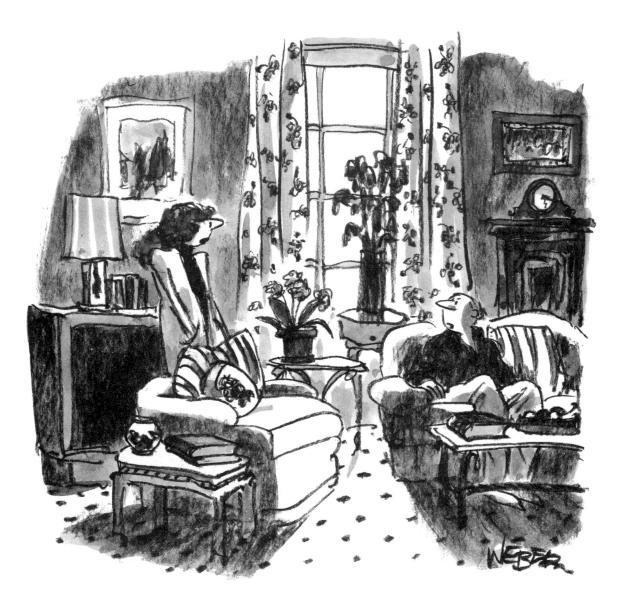

"*Of course I love you. If I didn't love you, we wouldn't have all this damn furniture.*"

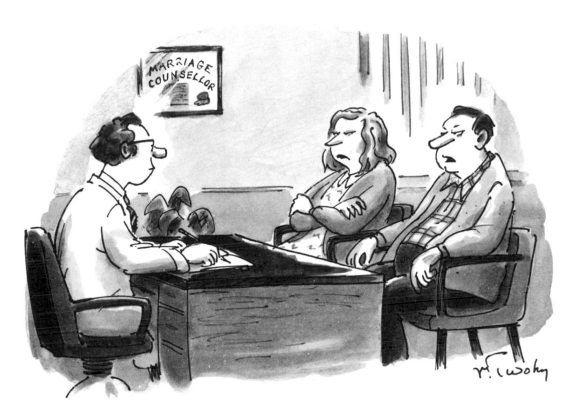

"*No heroic measures.*"

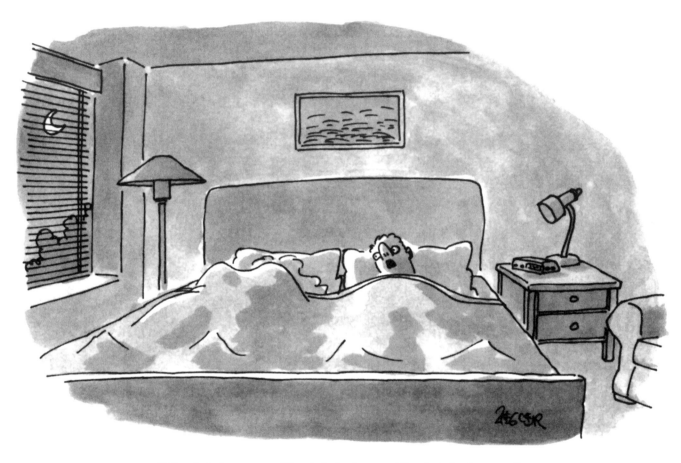

"Goodnight moon. Goodnight house. Goodnight breasts."

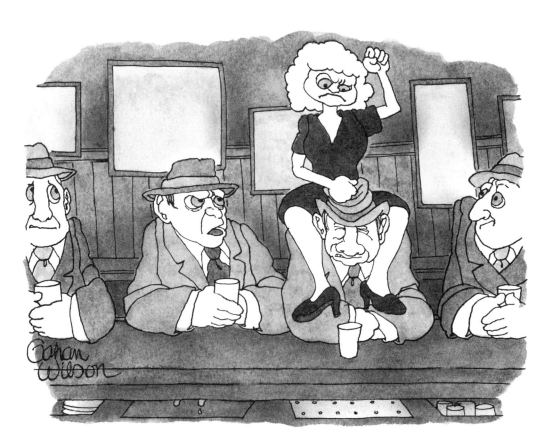

"She's no good for you, Harry."

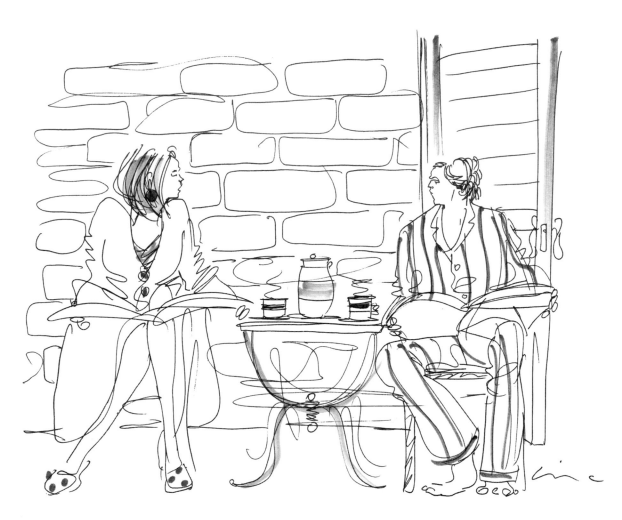

"So *this* is infidelity."

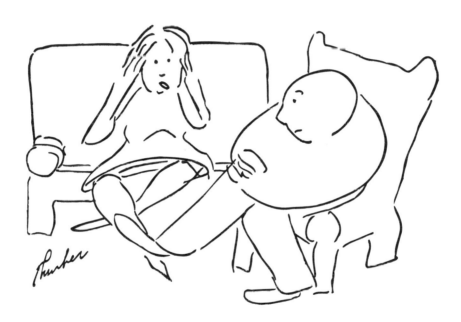

"With you I have known peace, Lida, and now
you say you're going crazy."

STEINBERG

51

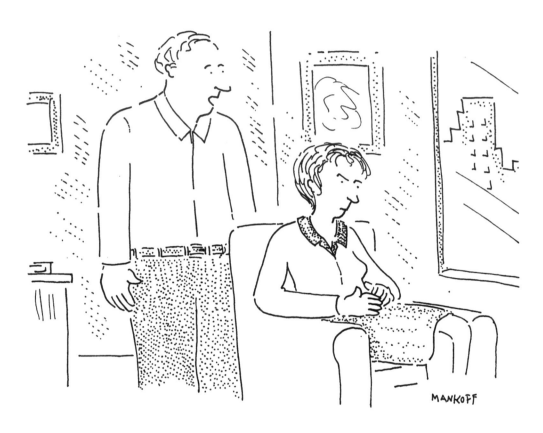

"So, *how's your snit coming?*"

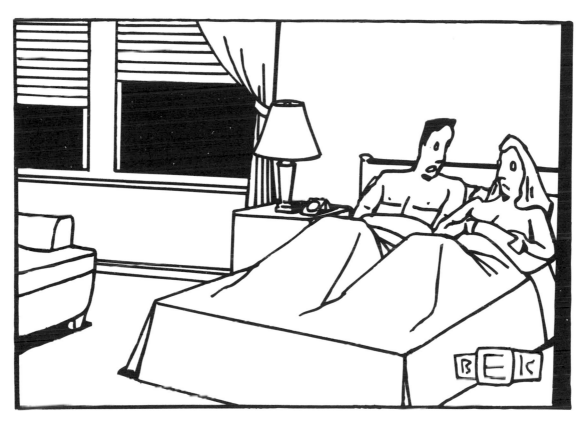

"Do you want to get out of here and grab a cup of coffee?"

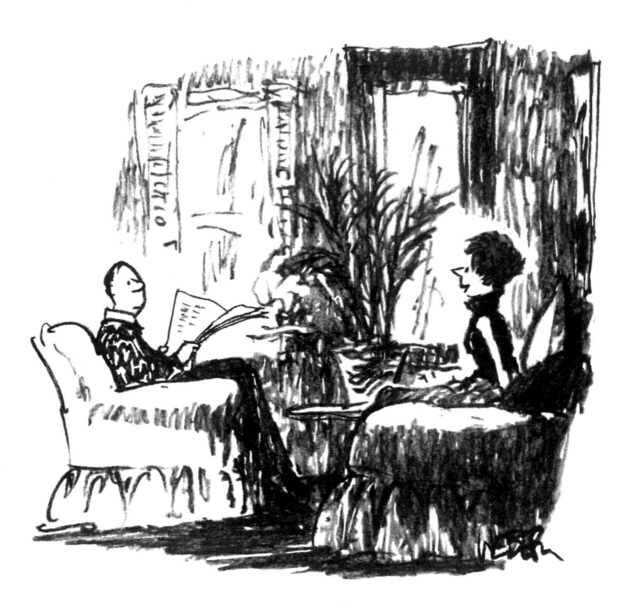

"*Dr. Stolner says it might be nice if I let you see my dark side.*"

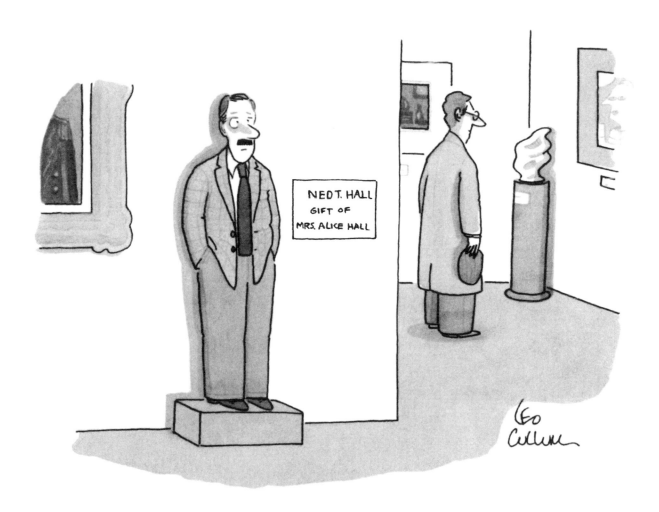

NED T. HALL
GIFT OF
MRS. ALICE HALL

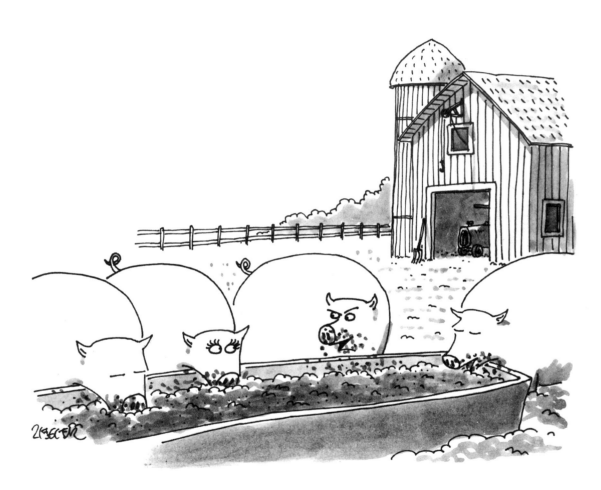

"Step a little closer, baby, and let some of the magic rub off."

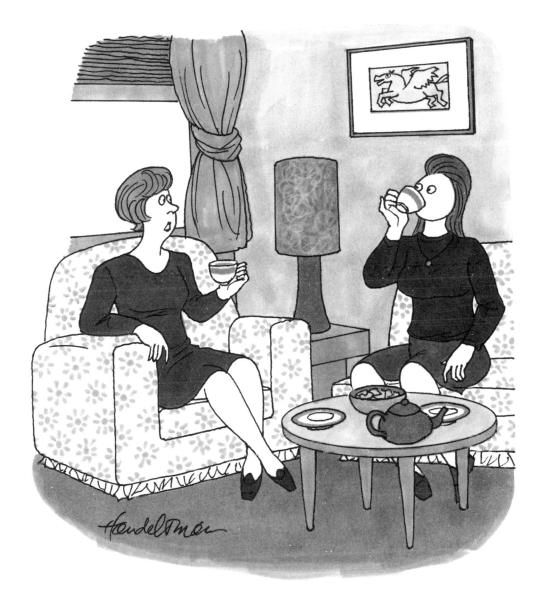

"Fred is heterosexual, but I wish he'd be
a little more blatant about it."

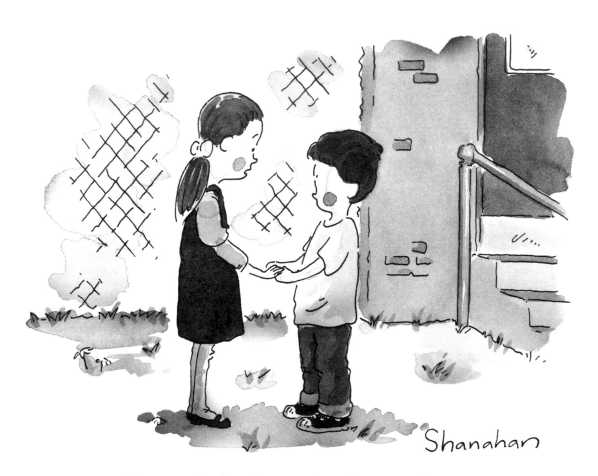

"*I'm sorry, Nathan, but I need to color outside the lines.*"

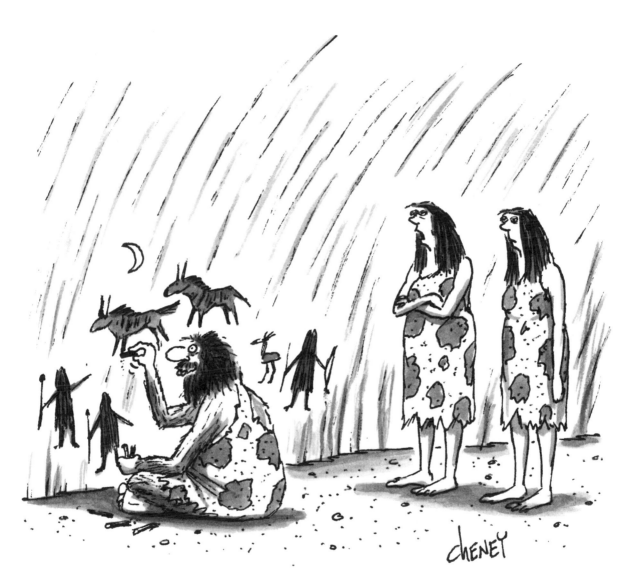

"I've had to be both hunter and gatherer."

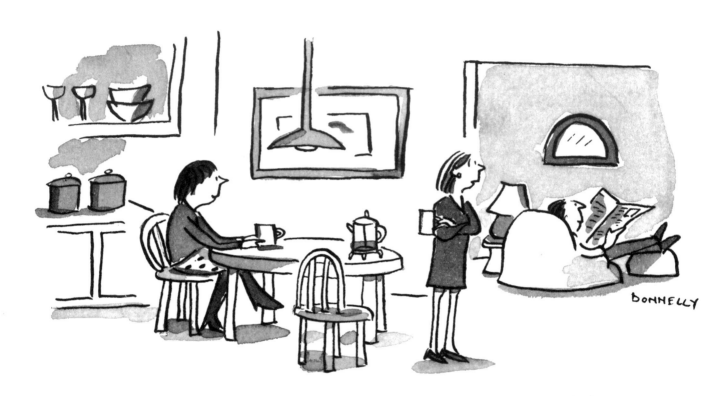

"I've got him right where I want him, now that I don't want him."

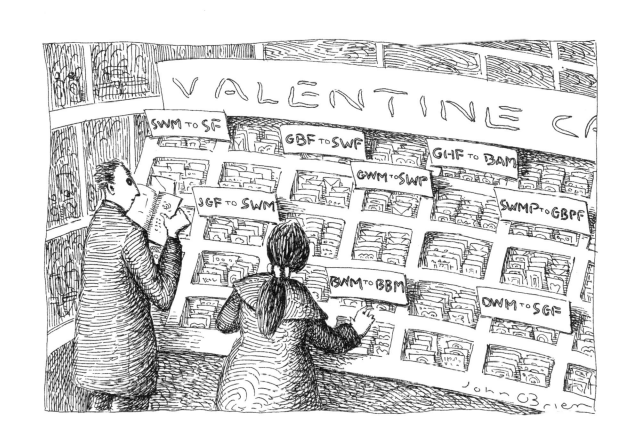

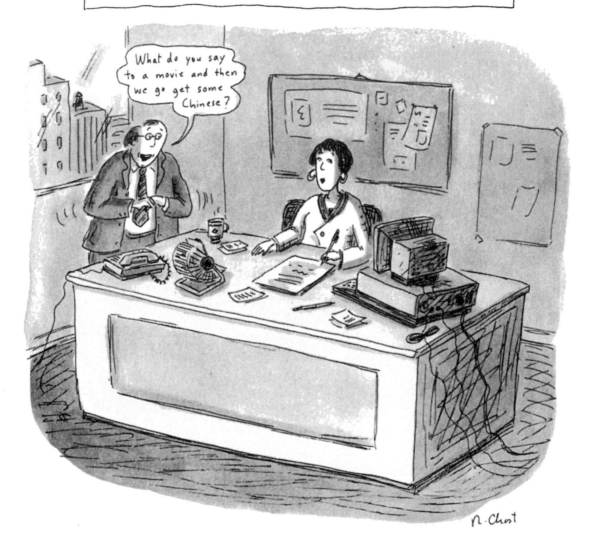

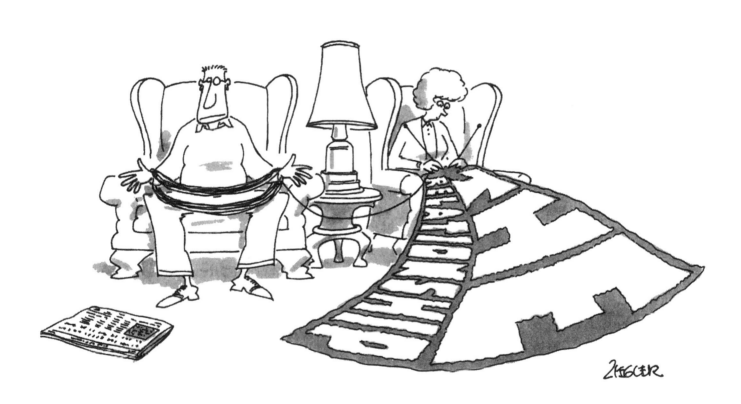

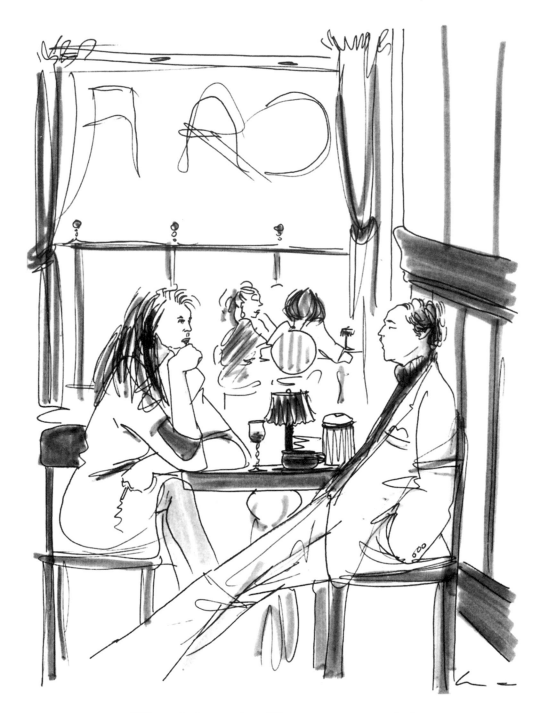

"Your clock may be telling you to get married,
but mine's telling me to have lunch."

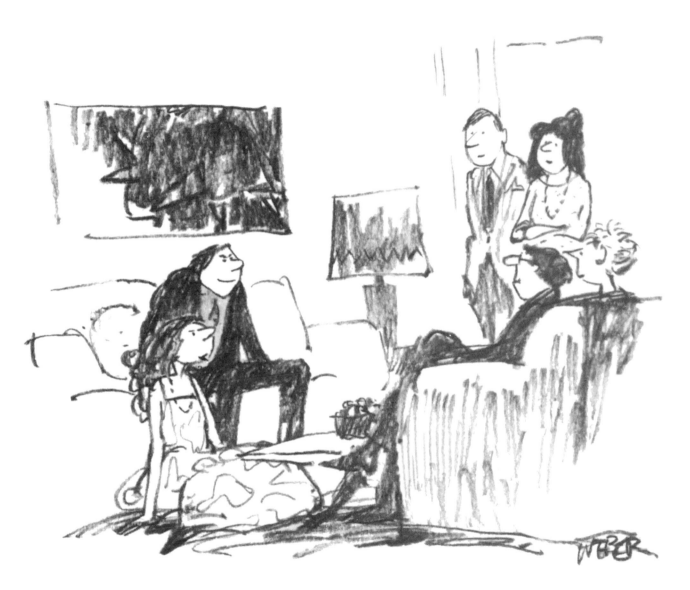

"Loving involves risk, but Michael and I are pretty courageous people."

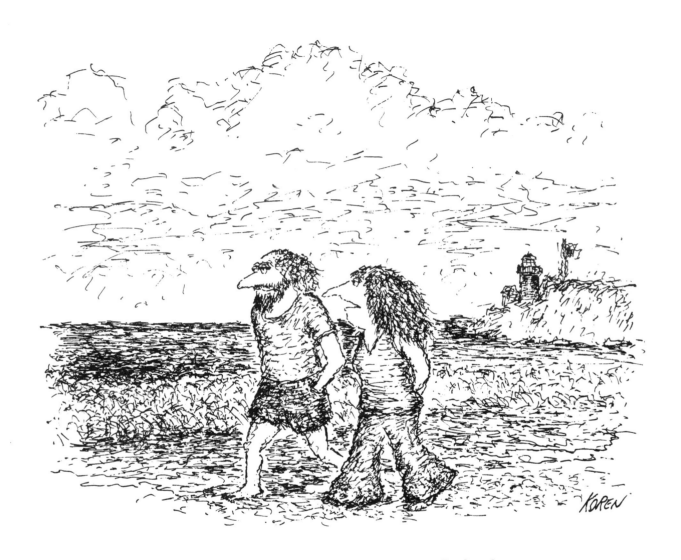

"I *do* think your problems are serious, Richard.
They're just not very interesting."

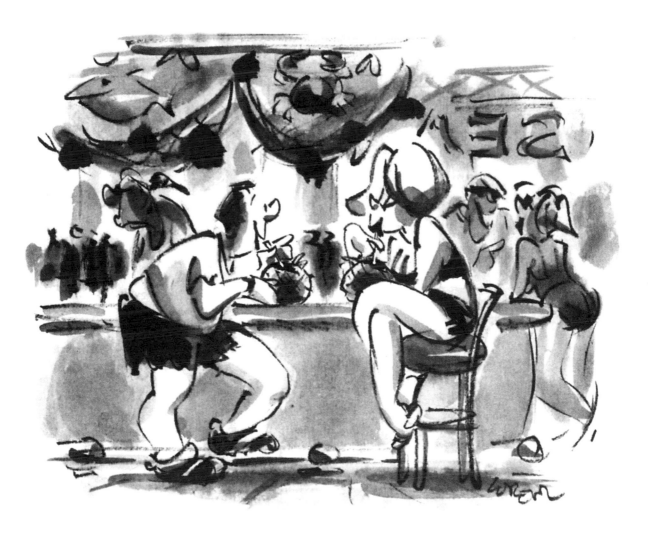

"*Now, don't go calling the sex police, or anything, but I think you're swell.*"

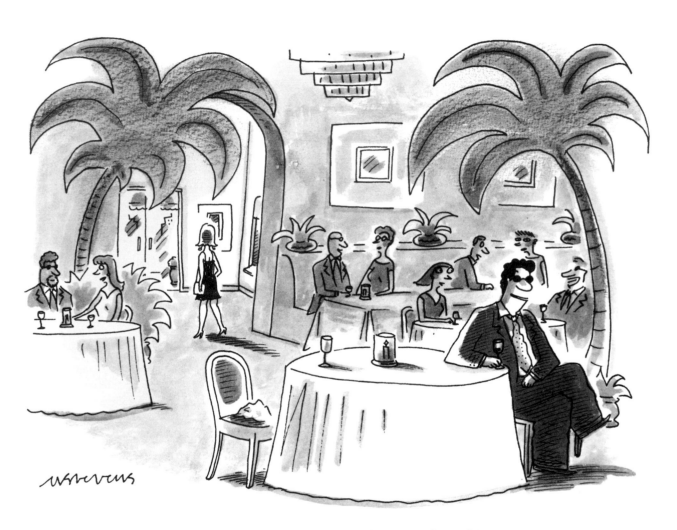

"The sound of violins, the night, the wine, the ambience—
but most of all, Louise, _you!_"

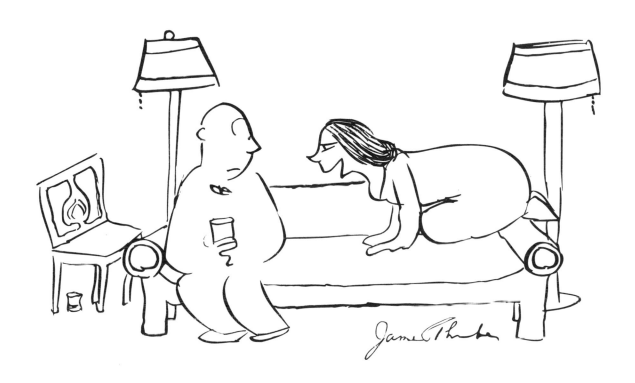

"The trouble with me is I can never say no."

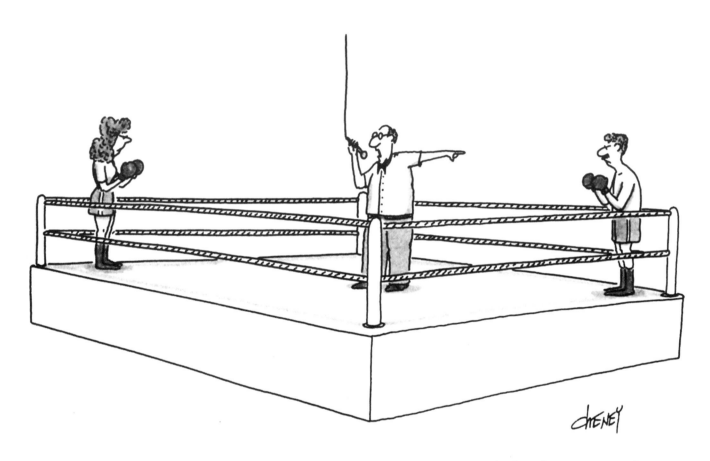

"And in this corner, wearing the blue trunks, weighing in at a hundred and seventy pounds and insisting that the dining room should not be decorated in lime and oak tones but, rather, with a pastel canary-yellow and walnut trim . . ."

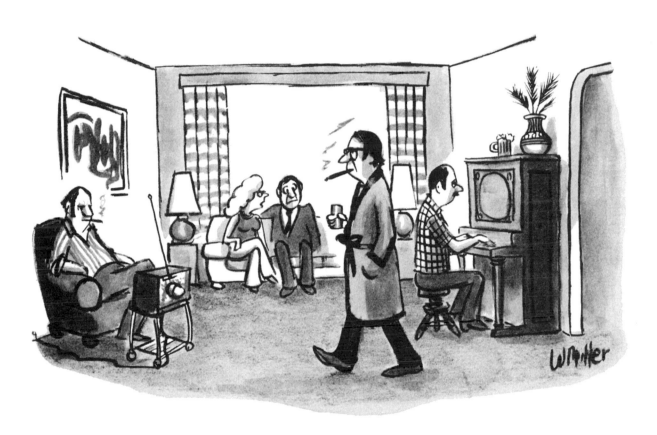

"Look, will you forget about them? They're in the past. The important thing is what I feel now—about you!"

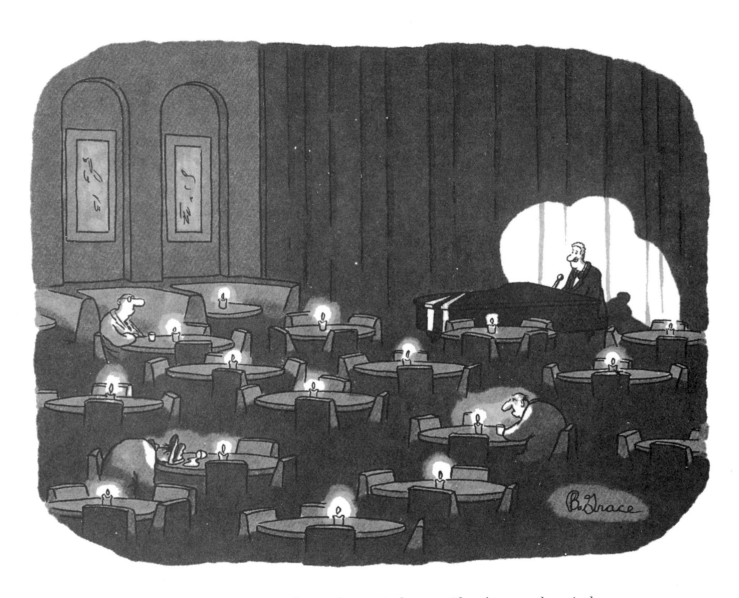

"And now, for all of you out there who are in love, or if you've ever been in love, or if you think you'll be in love someday, or even if you only think you might like to be in love someday, this song is for you."

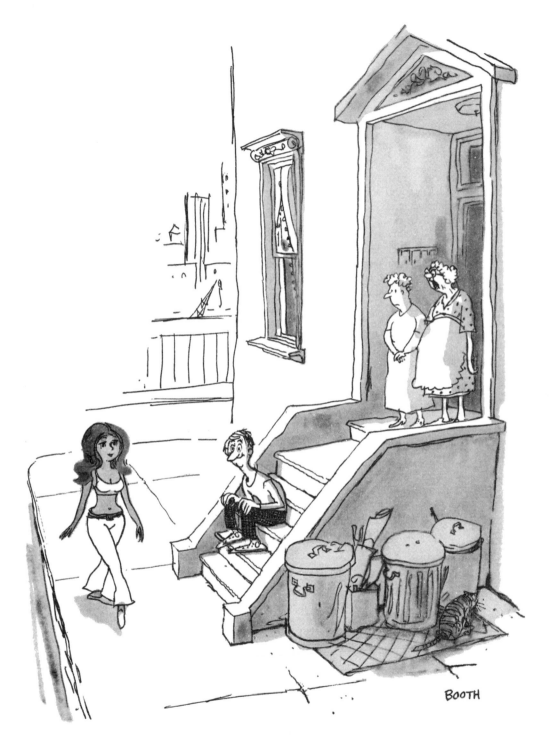

"Whistle, you dumb bastard!"

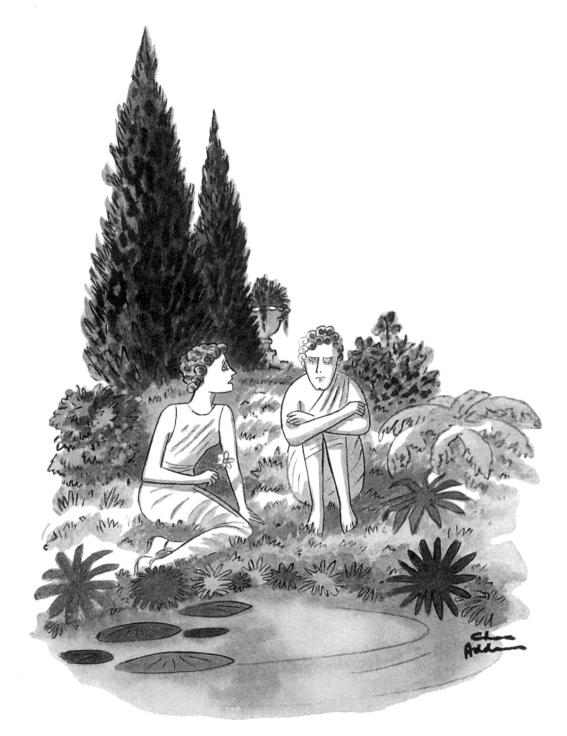

"Is there someone else, Narcissus?"

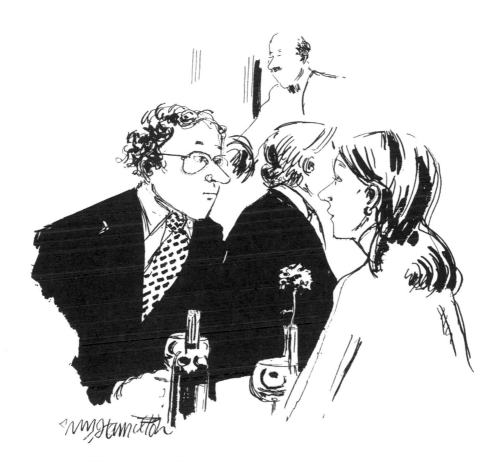

"When I fell in love with you, suddenly your eyes didn't seem close together.
Now they seem close together again."

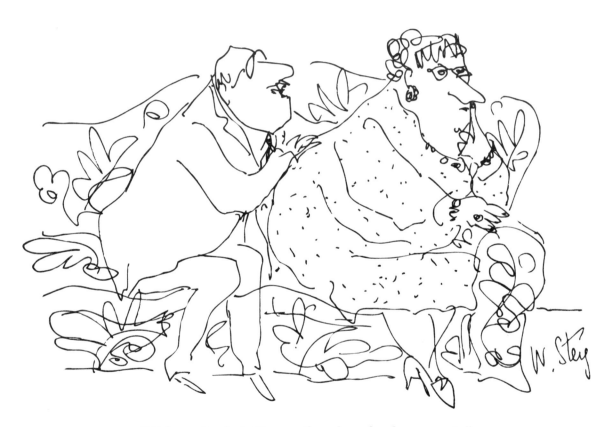

"*Celeste, I admit I'm not fit to breathe the same air.*"

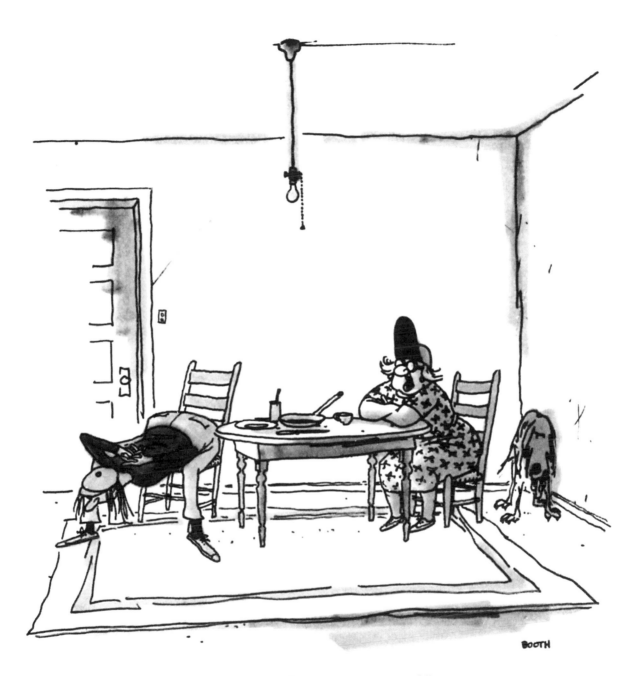

"*True love, Leon, is not corporeal.*"

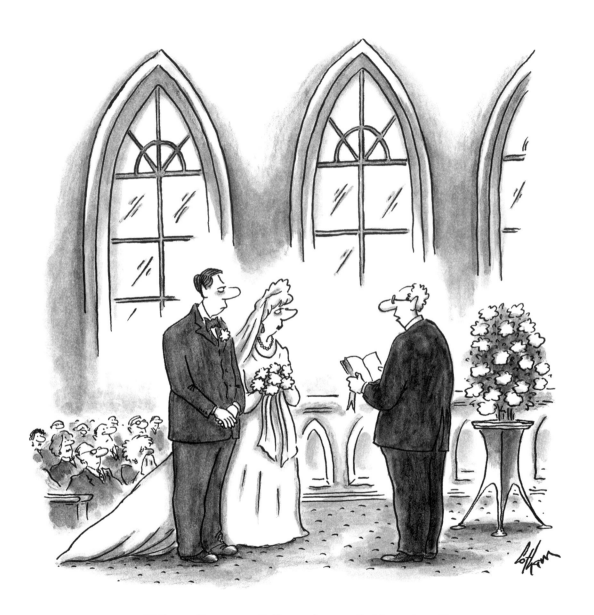

"*Please listen carefully to the available options.*"

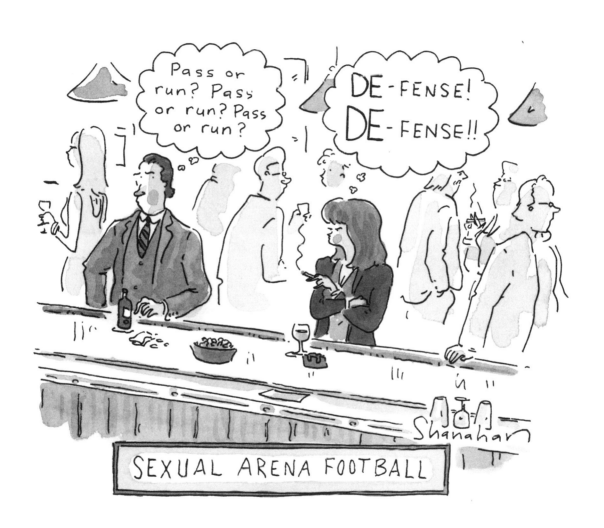

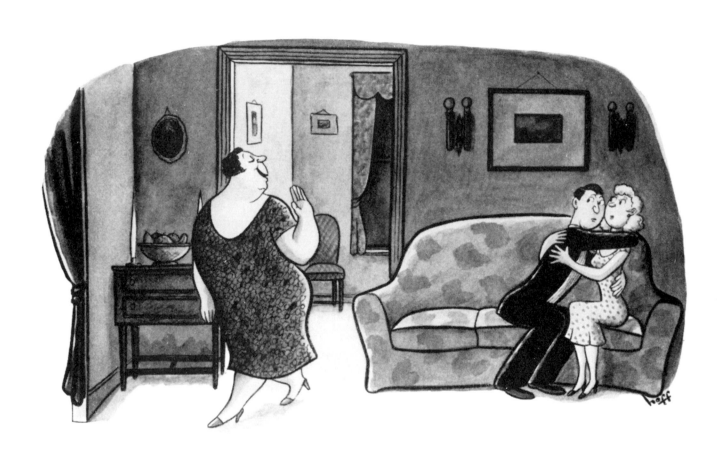

"It's all right, children. Don't even budge."

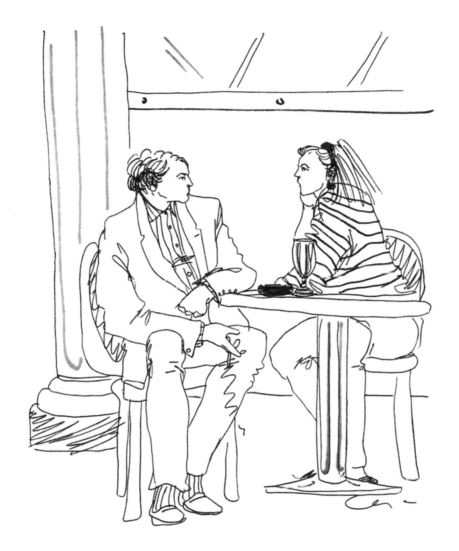

"*Let's date to see if we should go out.*"

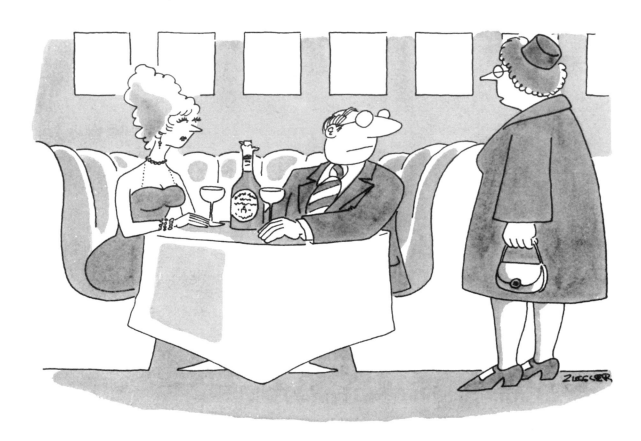

"No, I'm not jealous, Henry. Just hurt and a bit puzzled."

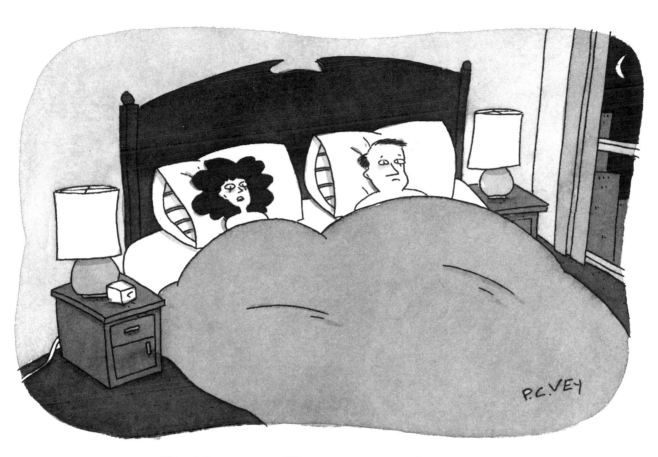

"Don't be too upset. If we were meant to have good sex,
we probably would have married other people."

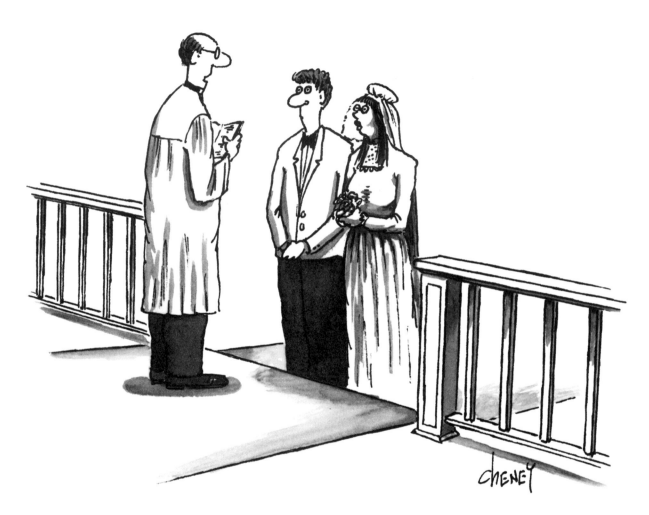

"*And do you, Rebecca, promise to make love only to Richard, month after month, year after year, and decade after decade, until one of you is dead?*"

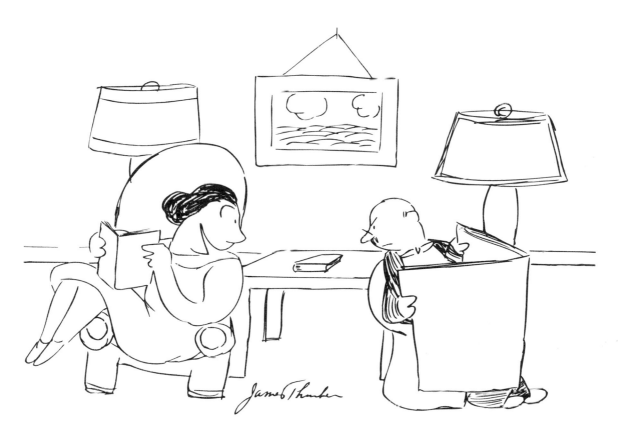

"It's our *own* story *exactly*! He bold as a hawk, she soft as the dawn."

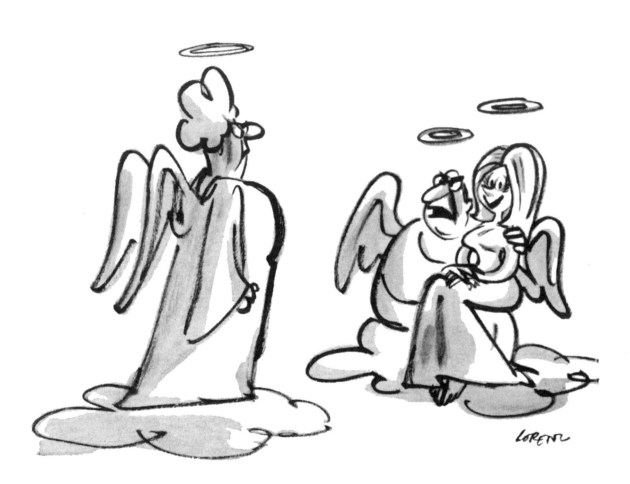

"*Buzz off, Louise! That was only till death us did part.*"

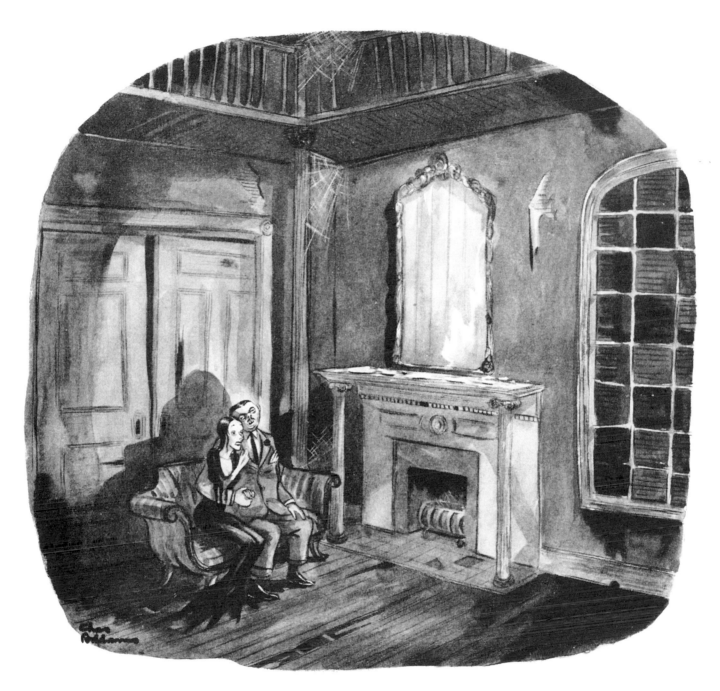

"Are you unhappy, darling?"
"Oh, yes, <u>yes</u>! Completely."

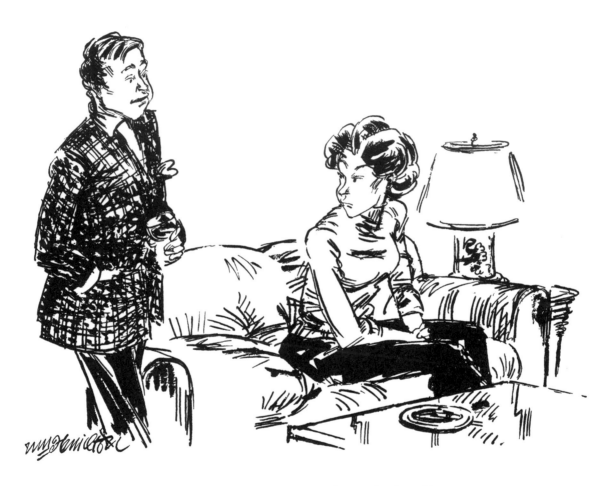

"*You know what I bet it is? I bet we're breaking up
but we just don't realize it yet.*"

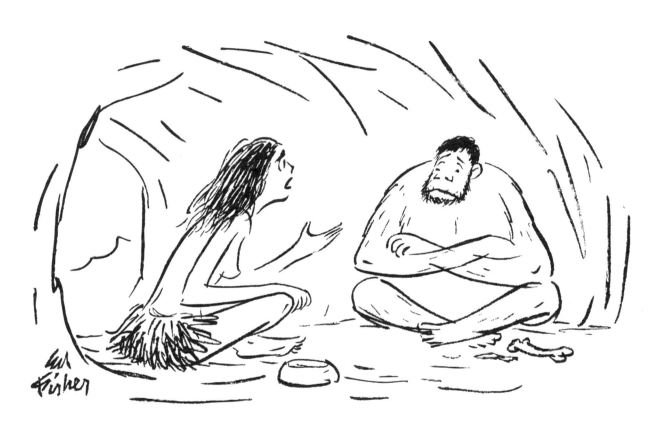

"It isn't that I don't love you. It's just that I've evolved and you haven't."

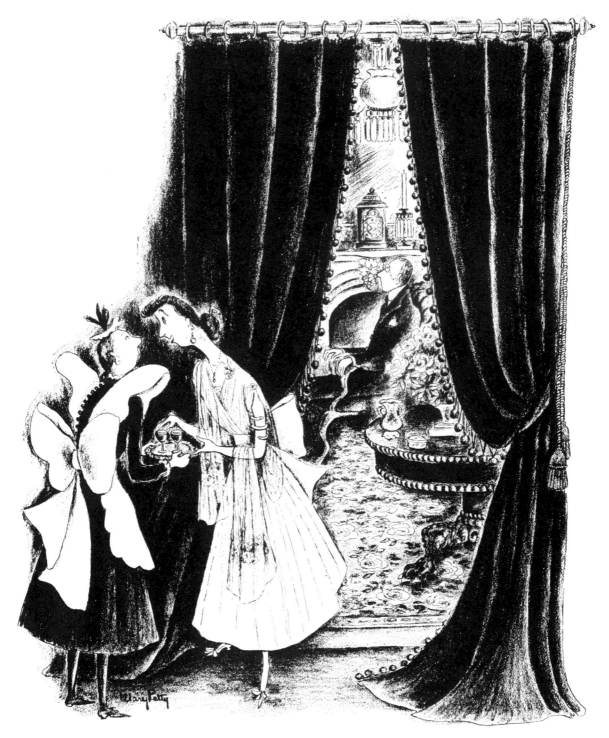

"Which one is the love potion?"

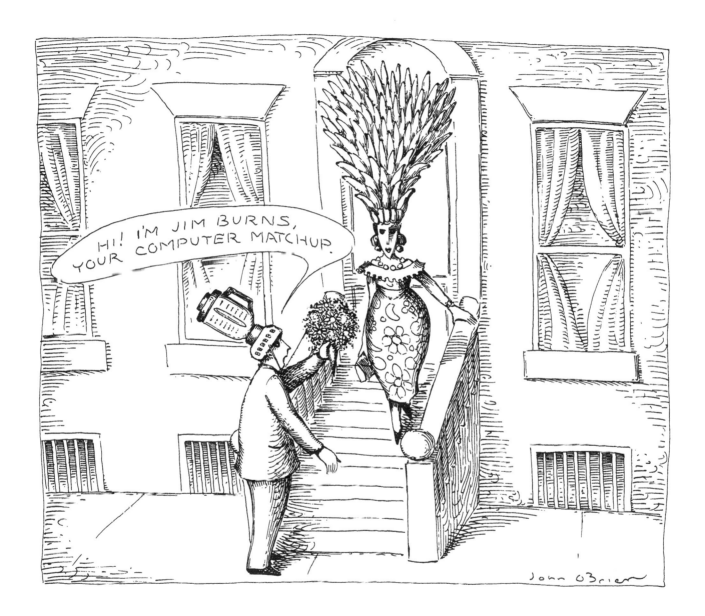

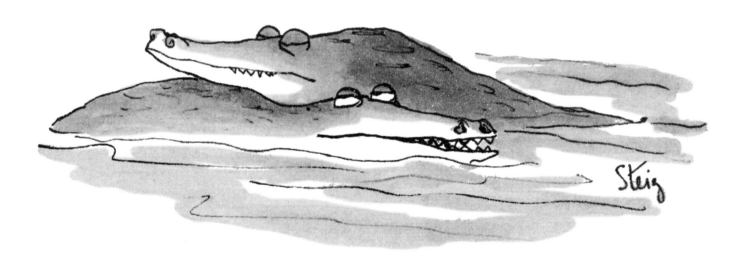

"*Love me?*"

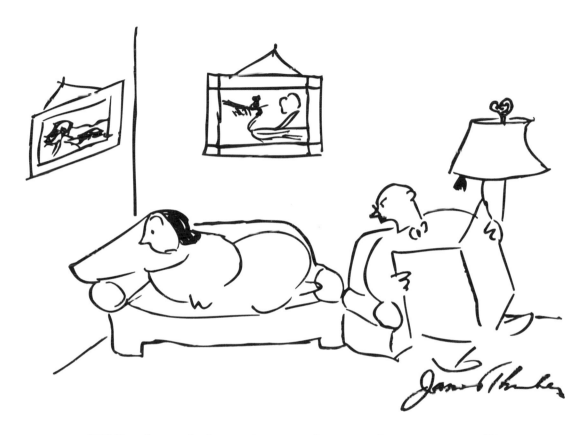

"*Well, who made the magic go out of our marriage—you or me?*"

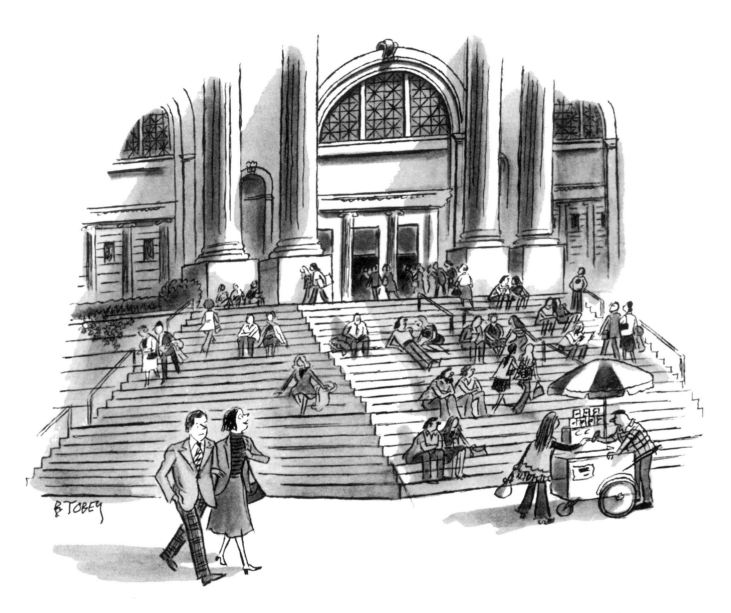

"Remember? I was sitting right up there when you came by and said, 'Hi, beautiful!'"

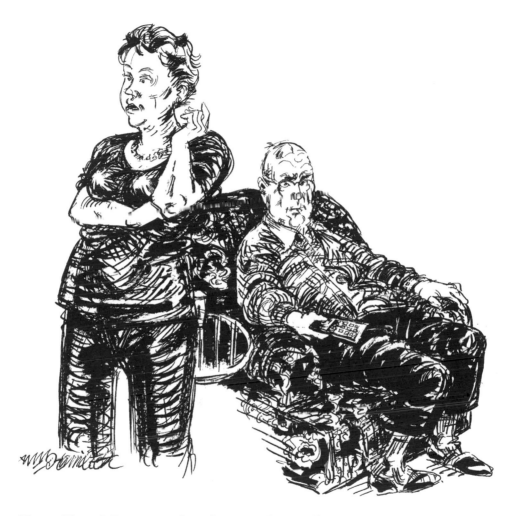

"*Jesus Christ! Do you realize that now I actually <u>am</u> fifty when you're eighty?*"

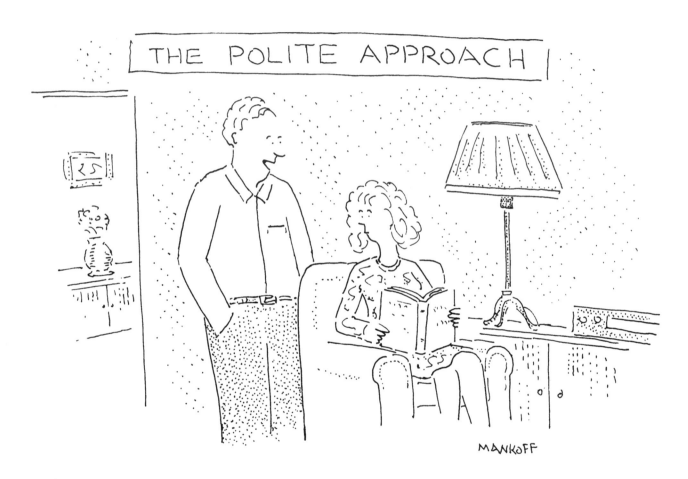

"*Can I trouble you for a sexual favor?*"

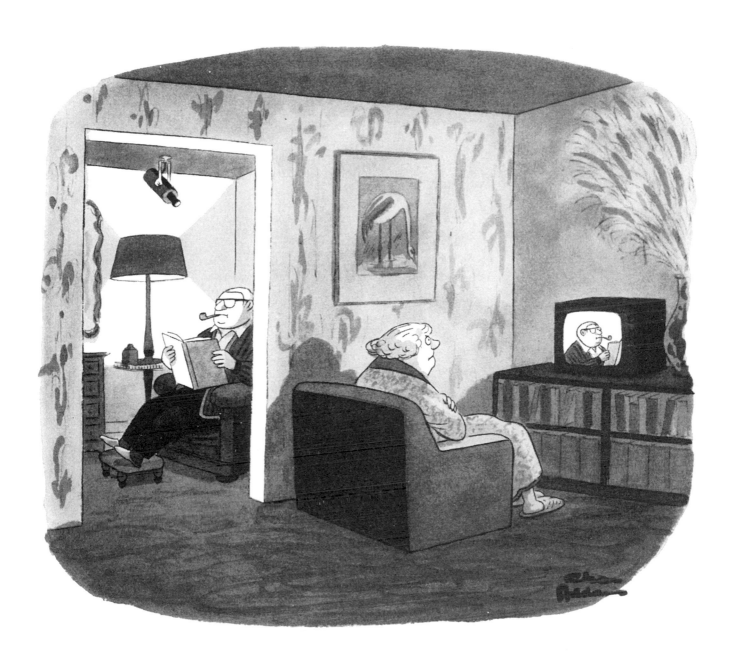

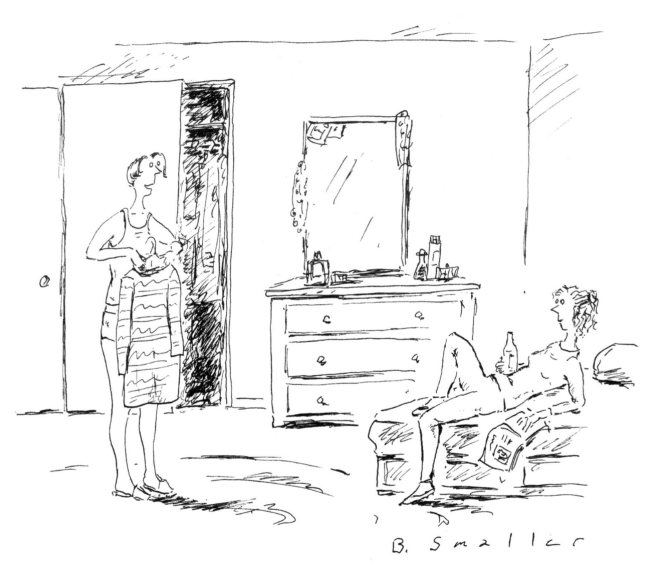

"It's not a completely blind date—he sent me some promotional material."

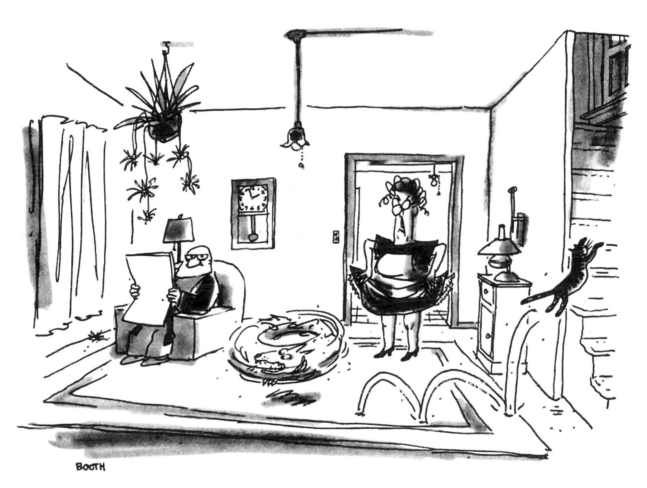

"Harold, are my knees bumpy?"

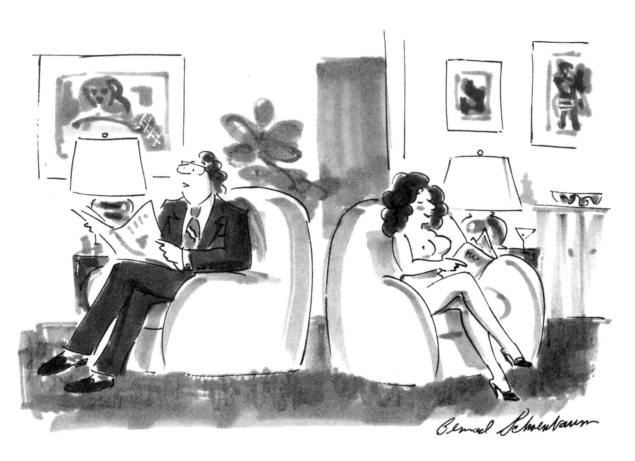

"Any plans for this evening, hon?"

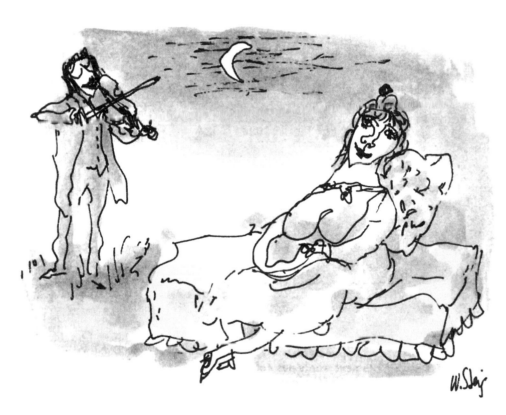

Love's Old Sweet Song

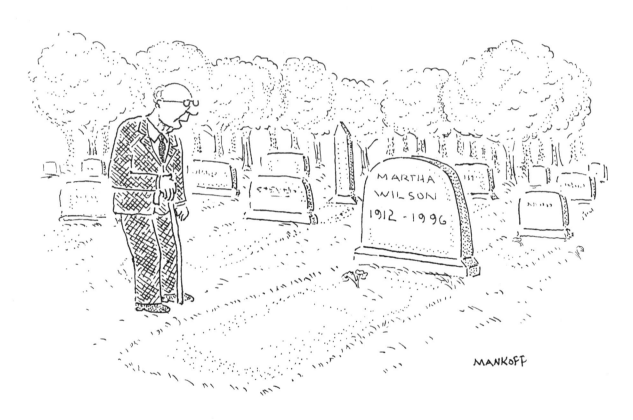

"*This is my last visit, Martha. I got the marriage posthumously annulled.*"

Index of Artists